MW01506364

POSTCARD HISTORY SERIES

Oconomowoc

Henry Schuttler built Mon Bijou (My Jewel) in 1879 for his bride, Maria Anheuser, of the St. Louis beer brewing family. Today it is known as the Pine Terrace Bed and Breakfast, and it is on the National Register of Historic Places. A good portion of the gardens rolling down to Fowler Lake now are occupied by condominiums. The estate's park on the lakeshore remains a private park with gazebo. (Courtesy of Jonathan Abbott.)

On the front cover: The shores of Lac La Belle and Fowler Lake lend themselves to taking one's ease. Varying versions exist on the origins of Lac La Belle's name. One of the more heavily documented is that the glistening body of water is named after fur trader Pierre La Belle who worked in land acquisitions for Solomon Juneau, founder of the city of Milwaukee. (Courtesy of Rae Kinn.)

On the back cover: Sailboats hit their markers during just another tranquil and serene day on Oconomowoc Lake. (Courtesy of Rae Kinn.)

POSTCARD HISTORY SERIES

Oconomowoc

Mary A. Kane

ARCADIA
PUBLISHING

Published by Arcadia Publishing
Charleston, South Carolina

Printed in the United States of America

Library of Congress Catalog Card Number: 2006928973

For all general information contact Arcadia Publishing at:
Telephone 843-853-2070
Fax 843-853-0044
E-mail sales@arcadiapublishing.com
For customer service and orders:
Toll-Free 1-888-313-2665

Visit us on the Internet at www.arcadiapublishing.com

*This book is dedicated to the memory of Sarah Jane Abbott (1912–2005),
the late Beverly Thomann, and the late Margaret Gibson.*

CONTENTS

ACKNOWLEDGMENTS

This book would not have been possible without the public-spirited generosity of Rae Kinn, who opened her postcard collection without reservations or restrictions. Others who were instrumental in their own ways are Jonathan Abbott; Bart Brown; Catherine and Bill Buckeridge; Donald J. Goergen O.P.; Harry and Betty Hancock; Chuck Herro; Kathy Kersten; Marilyn Laube; Nashotah House; the *Oconomowoc Enterprise*; Oconomowoc Public Library reference desk; Kevin Passon; Dorothy St. Thomas; Carolyn Hope Smeltzer; Sarah Williams-Berg; and Rev. Tom Winslow.

This book is dedicated to the memory of Sarah Jane Abbott (1912–2005) who, in the minds of many, reflected and often set the platinum standard for civic-mindedness as Oconomowoc has known it. It also is dedicated to the memory of two Ripon, Wisconsin, women from whom I learned the joys of researching and writing authentic and accurate local history—the late Beverly Thomann and the late Margaret Gibson; we three worked to publish the book *When A Woman Wills*, a history focusing on pioneering women, published in 1981 as a project of the Ripon branch of the American Association of University Women.

INTRODUCTION

It is widely understood that Oconomowoc developed and evolved in four distinct eras or phases. Until Charles Sheldon, the first white settler, arrived in 1837, the entire area was a fertile one tended by Native Americans who fished its lakes and streams and hunted its woods, marshes, and wide open spaces.

Paleo Indians were the first residents of Waukesha County, where Oconomowoc is situated. They are believed to have arrived in southeastern Wisconsin in 10,000 BC. It is said the Paleo Indians were drawn to the region in large part due to the abundance of elk and deer.

The Woodland Indians were known as mound builders. Experts regard the town of Summit outside Oconomowoc as one of the richest in the state in archaeological remains. The Winnebago tribe is said to have constructed effigy mounds that date from 100 BC through AD 1600. Summit's mounds often were shaped like lizards, panthers, and other species. "Holy Mound," shaped like a turtle and 150 feet in length, was preserved on Silver Lake.

The Potawatomi Indians, descendants of the mound builders, were the area's sole dwellers from about 1700 until the arrival of the first white settlers in the 1830s. The Sauk Indian chief Blackhawk is reported to have had a campsite on Oconomowoc Lake.

The Black Hawk War of 1832, an 1833 treaty, and a small pox epidemic shortly after the arrival of white settlers all contributed to the disappearance of Native Americans from the region.

However, it was the American Indian trails that Sheldon followed as he made his way from Mineral Point to the Oconomowoc area and launched the second pioneering and settling era. A New York native, he had come to Wisconsin in 1835 at age 22. It is said that he was lured to Oconomowoc upon reading a flattering portrayal of it in the *Milwaukee Advertiser*.

Upon arriving in Oconomowoc, Sheldon immediately staked a claim to a 160-acre tract of land on the east shore of Fowler Lake, registering it on April 21, 1837, with the Land Bank of Milwaukee. Oconomowoc acquired a new settler that same day when Sheldon recorded his claim and made the acquaintance of H. W. Blanchard, who then traveled back to the area the next day. Within days, Blanchard laid claim to a tract adjacent to Sheldon's.

In relatively short order, Blanchard sold his tract to Philo Brewer, who, in turn, sold off two-thirds to John S. Rockwell and A. W. Hatch. Brewer constructed the first residence within what are now Oconomowoc's limits, a log cabin with a shake roof on a parcel that now bears the address 517 North Lake Road.

Oconomowoc's first three residents wasted no time in building a dam across the Oconomowoc River and establishing a saw- and gristmill near the site of the present Lake Road bridge.

Rockwell, who has been characterized as "public-spirited," was instrumental in creating the fire department, library, an elementary school, and a young women's seminary and gave land to several churches. He also guided the construction of a road between Oconomowoc and Mayville and successfully lobbied to have Watertown Plank Road extended from Milwaukee to the newly settled area. In 1842, he started the Old Red Mill on Lac La Belle and built a hotel the following year. Rockwell Place and Rockwell Point, on which Zion Episcopal Church stands, are named in his honor. He died at age 53 in 1863.

Meanwhile, Sheldon lived for 10 years in what has been depicted as a crude shanty on a creek bank. It was only after farming the land for those 10 years that Sheldon built a home at its north

end. A portion of the property is now occupied by La Belle Cemetery, and Sheldon Avenue is named in his honor.

With the 1852 extension of Watertown Plank Road and Rockwell's additional efforts to bring the railroad to Oconomowoc, the area embarked on its next phase in which it rivaled Lake Geneva for the title of "Newport of the West."

By the 1870s, the first wave of wealthy sojourners from Chicago, Milwaukee, and St. Louis was turning the entire area into a summer resort, then a settlement of summer homes that, in decades to follow, would become year-round residences. Many were the magnitude of palaces and castles with 50 or more rooms, particularly those on Oconomowoc Lake as well as some on Lac La Belle and, to a lesser degree, on Fowler Lake.

Oconomowoc was incorporated as a city in 1875. Ten years later, in 1885, its population had swelled to 3,000. As the city of Oconomowoc's own identity solidified around its two "downtown lakes," so did that of Oconomowoc Lake, which was part of the town of Summit until the village of Oconomowoc Lake was established in 1959.

Gifford Resort on Oconomowoc Lake was a major tourist destination for wealthy Midwestern visitors during the 1890s. That led to the building boom of the 1890s when mansions of 40 to 50 rooms, called "cottages," sprang up around the lake—summer homes to beer barons, railroad tycoons, manufacturers, and politicians from Milwaukee, Chicago, and St. Louis.

Fowler Lake got its name shortly after the Blackhawk War when Albert Fowler was hired as a new fur trader and came to the area. Although it was half tamarack swamp at the time, Fowler put his name on the body of water where he also built his fur storage hut.

Some accounts report that Lac La Belle is named after a missionary or fur trader named La Belle, but such statements appear apocryphal at best.

One early link among the three lakes—La Belle, Fowler, and Oconomowoc—was the mail boat, which originally traversed the two lakes downtown. As Oconomowoc Lake's summer population grew, the Oconomowoc River level was raised with new locks constructed near Beach Road, accommodating boat passage.

Meanwhile, downtown, between the 1870s and 1930s, Lake Road was known as Presidents' Avenue, as much for the prominent national and international visitors who frequented the stately Draper Hall on Fowler Lake as for their visits to private residences across the road on Lac La Belle.

There are claims that, at one time during the era of opulence, there were 97 millionaires living in the Oconomowoc area. A list of 30 names does exist. It includes Milwaukee beer barons Gus Pabst and Frederick Miller; Chicago pork packer Philip Armour and catalogue mogul Montgomery Ward; and boat motor inventor Ole Evinrude and dairy baron Frederick Pabst.

The era of lavish living and legendary entertaining began to wane in the 1930s and further drew to a close as a result of World War II. Post-war Oconomowoc was a hub of commerce and industry. While the names and faces of some of the original ventures have vanished, others such as Carnation and Brownberry Ovens remain prominent household names nationwide.

Entrepreneurship over the years has led Oconomowoc to follow growth trends in light industry and technology and office parks. Now it is not so much a far-flung "exurb" of Milwaukee as it is a widely sought-after living destination for those who live and work in Oconomowoc as well as those who commute to both Milwaukee and Madison.

One

La Belle and Fowler
Meeting Waters

One interpretation of the Native American term out of which the city name Oconomowoc grew is "meeting of the waters." Indeed, the heart of Oconomowoc is graced by two glorious, storied bodies of water—Lac La Belle and Fowler Lake.

Just west of the present North Lake Road bridge, the first dam at Lac La Belle was built in 1837, thereby creating Fowler Lake. Washed away and rebuilt twice by 1843, a plank road was built at the top of the dam by pioneering resident John S. Rockwell. Travelers paid a toll for using the bridge and the road. In 1885, a navigational lock was built between La Belle and Fowler Lakes. Those underpinnings set the stage for what became "the Newport of the West" of the late 1800s and early 1900s and what continues to this day to be idyllic lake living.

Capt. Budd Parsons built and launched one of the first boats, the *La Belle*. By 1853, Dr. James Lewis had organized the first boat club. That same year, another club called the Scow Club was formed. The Oconomowoc Yacht Club was organized in 1878, holding its first regatta on August 25 of that year. By 1887, the yacht club had more than 100 members with a fleet of 20 sailboats and a good measure of Oconomowoc's summer social calendar revolved around its activities on Lac La Belle.

Not to be outdone, Fowler Lake, though not large enough for sailboat races, was a focal point for many visitors drawn to the grandeur of Draper Hall, a rambling structure with a seven-column, three-story colonnade across its front. North Lake Road for a period of time was known as Presidents' Avenue because Presidents Cleveland, Taft, Grant, Coolidge, McKinley, and Teddy Roosevelt all had been guests at Draper Hall. Before becoming a bed and breakfast now listed on the National Register of Historic Places, Pine Terrace on Fowler Lake was a private residence built by Henry Schuttler, the Chicago wagon manufacturer. Both he and his brother married into the brewing families of Anheuser and Busch. The estate had 220 acres of forest and farmland, with a large flower garden and lawn rolling down to the north shore of Fowler Lake.

The downtown Oconomowoc lakes for many years were a major national wintertime draw, playing host to the U.S. Olympic Skate Trials. Many of Oconomowoc's notable industrialists and business leaders served as officers and on the trials' advisory committee.

Draper Hall was the center of activity on the Fowler Lake shore of Lake Road for several years and through several phases of owners. The original structure contained a store and was built by W. W. Collins and George W. Fay. It also held sleeping rooms, a dining room, an office, and a hall. Next, Dwyer Poplis operated a boardinghouse there that could accommodate about 25 guests. When Martin P. Draper purchased the property in 1869, a new era of grandeur made Draper Hall a national tourist destination.

Draper Hall's famous pillars were added in 1889 when the upper two stories were added. Local lore has it that the pillars were called "the seven bridegrooms" because Draper allocated funds from seven honeymooning Chicago couples to underwrite the cost of the pillars. Lavish furnishings and decor included a lounge with open fireplace and grand piano and a dining room with an ornate skylight.

DRAPER HALL BOAT HOUSE, LAKE LAC LA BELLE
OCONOMOWOC, WIS.

The open wooden gathering spot known as the Draper Hall Pavilion, also a boathouse, was designed to host many dances and other galas over the years. Draper Hall was closed during World War I because the social scene was on hiatus. It was purchased in 1922 by Mrs. C. E. Kohl, who owned the Majestic Hotel and other real estate. Her efforts to restore Draper Hall's original luster fell short of her extensive investments, including repairs she made following a $50,000 fire in 1927. Several owners during the 1940s and 1950s also were unable to stage a full-scale revival of the Victorian-era gem. However, an invitation kicking off the 78th season on Memorial Day weekend 1941 conveys the landmark's spirit: "the portals of Old Draper Hall will swing wide as we greet and welcome Old Friends and New, that you may enjoy the time-mellowed beauty of this charming hostelry and its surroundings, together with modern comfort and convenience."

In addition to some half-dozen U.S. presidents, Draper Hall played host to President Garfield's assassin, Charles Julius Guiteau, and to Prince Henry of Prussia. Women's suffrage advocate Phoebe Cozzens also was a guest as were actor Joseph Jefferson and poet Eugene Field.

Beneath the canopy, on either side of the entrance to Draper Hall, stood two griffins placed there in the 1950s by a descendant of the C. E. Kohl family, former owners. The griffins have their own storied past, having been acquired by the Kohls for use in their theater and circus business. The Kohls' acquisition came from the front entrance to Chicago's most famous bordello, run by the Everly Sisters. The griffins were purchased by the Oconomowoc Library in 1967, guarding the front door of the former library on North Lake Road and now residing in the interior entrance of the new library on South Street.

The Sisters of St. Dominic were the last owners and occupants of Draper Hall. They renamed it Villa St. Ann and operated it as a home for elderly women. The Dominican sisters sold Villa St. Ann and its contents in 1967. It was razed and replaced by the current Draper Hall condominiums.

North Main Row, Oconomowoc, Wis.　　　　　　　　　　Mfg. for F. F. Esser & Son

North Main Row was just north of the former Oconomowoc Library on Lake Road.

Brookins Cottage, Oconomowoc, Wis.　　　　　　　　Mfg. for F. F. Esser & Son

The Great White Queen Anne of North Lake Road, as Henry Brookings' Cottage is also known, was constructed in 1889 on a parcel of land that had seen several earlier incarnations. Brookings Cottage is a paragon of Queen Anne architecture, featuring, among many other external touches, ornamental bargeboards, overhanging gables, and a classic veranda with columns, dentils, and medallions. Interior flourishes include octagonal rooms, Victorian fireplaces, and gas chandeliers and light fixtures, which have since been electrified. An extensive restoration preceded its June 2006 opening as the bed and breakfast Lake Manor.

Mississippi riverboat captain John Scudder, who had known Henry Brookings from their days in St. Louis, purchased land just south of Brookings' Cottage on North Lake Road and built his home in 1895. Scudder is said to have been so well known on the Mississippi River that he drew high-profile celebrities of the day to his Oconomowoc home, including Mark Twain and songwriter Alfred Robyn. Librettist Percieval Thorne is said to have finished his opera *Leonardo Da Vinci* at the Scudder residence. The C. E. Kohl family purchased the home in the 1920s, later selling it to the Order of Masons, which still owns it.

Wisconsin state senator George W. Dixon bought this 16-room Lac La Belle mansion in 1908 from David Gould, a St. Louis millionaire, who enlarged the original structure built in 1860. The interior featured 11 fireplaces, carved dragon tables, marble busts, and statues on pedestals. The lawns once occupied what now form the sites for three homes and were dominated by sunken gardens and tennis courts.

Simmons Play Grounds, Oconomowoc, Wis. Mfg. for F. F. Esser & Son

The Simmons Play Grounds was located along the Fowler Lake shore between Draper Hall and the North Lake Road bridge.

The Falls ,Oconomowoc, Wis.
(Showing Zion Episcopal Church and
St. Paul's Lutheran Church.)

E. C. KROPP CO. MILWAUKEE. no. 6890.

One of Oconomowoc's defining characteristics, the falls at the North Lake Road bridge, still has as its backdrop along Fowler Lake's shores both Zion Episcopal and St. Paul's Evangelical Lutheran Churches.

NORTH MAIN STREET BRIDGE, WHERE LAKE FOWLER AND LAC LA BELLE MEET, OCONOMOWOC, WIS.

Boaters wanting to catch the Fowler Lake waterfalls up close often skim their craft slowly under the North Lake Road bridge.

BEAUTIFUL SUNKEN GARDEN NEAR THE DAM WHERE LAKE FOWLER AND LAC LA BELLE MEET,

The sunken garden on Fowler Lake just south of the waterfalls and bridge was a feast for the eyes for those strolling along North Lake Road. It eventually gave way to construction of a Frank Lloyd Wright–designed home for local apple orchardist and beekeeper Carl W. Aeppler. It was built in 1955. Aeppler, a former high school manual arts instructor, designed his own honey jars and labels for his Land O'Lakes honey, a brand sold and served worldwide. Aeppler was a United States Cooperative Weather Service observer for 27 years, honored by Wisconsin governor Warren Knowles.

Clarence Peck, who bought this Oconomowoc landmark from his mother in 1878, later installed 10 Ionic columns imported from the 1893 Chicago Exhibition on the north wing of 430–434 North Lake Road. The columns are emblematic of the Classical Revival style, which gained momentum after the world's exhibition. The southernmost structure was built in 1846 by Martin Townsend for his son Hosea, Oconomowoc's first resident physician. The property had seen several earlier uses, including a structure that John S. Rockwell used as an office and also used for that purpose by village officials. In 1872, Mrs. Philip F. W. Peck of Chicago purchased the home and it remained in the Peck family for 51 years, serving as a center of lake social life and yachting. "Madame" Peck, as she was known, and her four sons are credited with elevating Oconomowoc's profile as a summer destination for Chicago's elite. John Stevens, a Milwaukee attorney, and his wife Lenore purchased the Peck house in 1923 and divided it into the two structures that each stand separately today at 430 and 434 North Lake Road. Much Classical ornamentation remains at 430 North Lake Road from the era of Clarence Peck's exhaustive renovations, including a large bracketed cornice, a pediment gable, a dining room with a 10-foot ceiling trimmed with elaborate molding, and expansive fireplace mantles.

SHORE LINE, LAC LA BELLE, SHOWING RESIDENCES OF
C. I. PECK, F. W. PECK AND GEO. WESTOVER, OCONOMOWOC, WIS.

The 19th-century gazebo at the lakefront of the Peck residences at 430 and 434 North Lake Road comfortably seats 15 to 20 people and was used as a judges' review stand during regattas on Lac La Belle. It is constructed with heavy timber beams that rest on concreted piers fixed deeply into the steep shoreline. Ornate decorative railings and post brackets make it a visual treat for boaters to this very day.

Farther along the shore from the Peck lakeshore gazebo, rolling lawns and lush trees create a seamless panoramic scene.

Ice boating on Lac La Belle was wildly popular for decades.

Ferdinand W. Peck built this home on North Lake Road, making for something of a string of residences in the Peck family and amounting to a family compound. Ferd Peck was cochairman of the 1893 Chicago Exhibition.

Lac La Belle shoreline usually manages to afford splendid views from the lake and tranquility and privacy for lake home dwellers.

Marjorie Ward, the adopted daughter of catalogue king Montgomery Ward, acquired the former Simmons estate in 1926, razed all the buildings, and constructed what can only be described as a French Provincial statement. It featured seven fireplaces, leaded glass windows, and numerous crystal chandeliers. Knollward, as she called it, was the setting for much lavish entertaining.

When Marjorie Ward married Robert Baker in 1932, she added another wing to Knollward. It was she who successfully petitioned the Oconomowoc City Council to have the name Main Street changed to Lake Road.

Legend and lore are only a part of catalogue king Montgomery Ward's legacy left to Oconomowoc. The generosity of his daughter Marjorie Ward Baker has helped to make Lutheran Homes of Oconomowoc's sterling reputation for senior resident living, including for many years at her former Knollward estate on Lake Road. Montgomery was proud of his status as a self-made millionaire. The story goes that from a stable-loft office in 1872, he sent out flyers advertising a $1 pocket watch and was flooded with orders. Ward's was the first mail-order catalogue business, a monopoly he held for 15 years before Sears gave him a run for his money. In commerce and in recreational pursuits, however, Ward kept his edge. When he moved to Oconomowoc, he quickly resolved to outdo John Dupee and Gus Pabst in the business of racing horses.

LA BELLE KNOLL DRIVE, OCONOMOWOC WIS. 1015

Montgomery Ward's first estate, a 300-acre farm on the west end of Lac La Belle, was home to Dexter, his prized racehorse for whom he built a track. Ward cared equally for his coachman of 20 years, John Easton, building him a home and taking him to the London International Horse Show of 1895 where Ward gifted Easton with a gold watch. In London, Ward earned grand prize for his tally-ho grand drag, a monogrammed carriage that boasted an embossed beige velvet interior, a ladies' water closet, and a velvet-lined wine bottle cabinet. Back at his Oconomowoc estate, Ward also had constructed a log gatehouse, which was a replica of one he had admired at the 1893 Chicago World's Fair. The library of the residence was filled with blue ribbons won by Ward's horses. The porch-encased home burned to the ground in 1909, leaving Ward despondent and ailing. He sold the estate to a millionaire seed merchant and built a home in Pasadena, California.

Montgomery Ward's widow and their adopted daughter Marjorie, who was also their orphaned niece, returned to summer at Draper Hall and eventually Marjorie had Knollward constructed on Lake Road, a project that took two years. The tract had more than 700 feet of shoreline. At age 40, Marjorie spurned the courting efforts of two Chicago physicians in favor of marrying Oconomowoc resident Robert Baker, who had lived next to Draper Hall and cared for his widowed mother for 20 years. Life at Knollward kicked into high gear, with lavish parties that spilled out onto the terrace and often featured big-name Chicago bands and cabaret floor shows. Indoors, a lower-level party room featured a bar, a mural of a jungle scene with elephants, and authentic zebra skins on the furniture. Anyone growing up in Oconomowoc for decades heard whispers about there being gold faucets in Knollward and that is because there really were gold faucets in the black marble sink in the master suite's bathroom. The original dwelling had 17 crystal chandeliers, seven fireplaces, and 30 rooms. Marjorie Ward Baker carried on her father's fondness for the animal kingdom by providing her Boston terrier Andy with a black marble bathtub as a present one Christmas. Andy received a proper burial in the Knollward yard, complete with a headstone.

Marjorie Ward Baker's generosity extended beyond her donation of Knollward to Wisconsin Lutheran Homes Incorporated. On one occasion, she underwrote new interior design and furnishings for the Oconomowoc Lake Club. The Knollward gift through her estate in July 1961 included funds for remodeling and addition of a new wing. It became a facility for retirees who did not require nursing care and gave first preference to couples, according to the provisions of Baker's will. Years later, when Lutheran Homes of Oconomowoc, as it became known, put the "showplace of the Midwest" on the real estate market for $3 million, the features of this "encore to an era" and "a monument paying tribute to an unsurpassed era of glamour, grace and style" were two Florida rooms, wall murals, marble fixtures, 23 bathrooms, built-in curios, "endless storage," and "breathtaking views of Lac La Belle." It has been returned to use as a private residence.

Island Dale,
Lac La Belle,
Oconomowoc, Wis.

Walter Peck purchased the six-acre Long Island on Lac La Belle in 1882 and constructed a three-story Queen Anne–style home with a widow's walk and 12-foot ceilings. A coach house and bandstand also were prominent features on the property. Peck owned two steam launches named *Adele* and *Wyomee*, and a sloop named *Ethel*.

Peck's Cottage, Oconomowoc, Wis. J. A. Herro Photographer and Pub.

The story has it that Mrs. Walter Peck declined to ride in a boat, so Peck had a four-block-long causeway constructed to reach the estate that became known as Islandale. First, a large pier was constructed to the island. Then, years later, a permanent road was constructed when 10,000 loads of gravel were poured out to the island. The permanent causeway was not built until after 1900.

Lindenmere, constructed on Round Island on Lac La Belle, was the estate of William Shufeldt. The main house was razed in the 1950s, but the boathouse still stands.

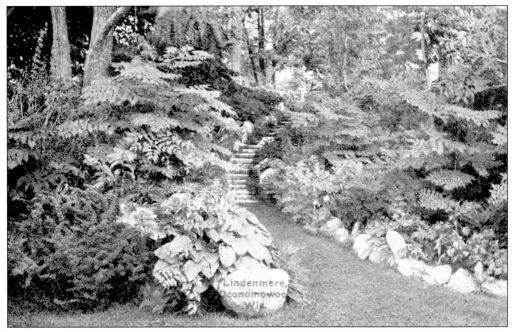

Lindenmere was the 1896 wedding gift to William Shufeldt and his bride Mary Kelly from his parents Henry and Emeline Shufeldt. When William died in 1910, Mary sold what was then called Kelly's Island to John Beggs.

Golf remains a major pastime and passion for many Oconomowoc residents and visitors. Lac La Belle golf course was one of the first golf courses in the area.

John Watkins Mariner, a real estate law magnate, also was a sports fan who brought golf to Milwaukee and laid out the golf course at Oconomowoc Country Club.

ROSEDALE COTTAGES, LA BELLE LAKE, OCONOMOWOC, WIS.

While the term "cottage" often was applied to mansions, other lakeshore structures were cottages in the true sense of the word as it is generally understood.

Resort Bridge, Oconomowoc, Wis. Mfg. for F. F. Esser & Son

Despite development of many sprawling estates, the Oconomowoc lakes boasted numerous undespoiled natural attractions.

RAPIDS. OCONOMOWOC RIVER. OCONOMOWOC. WIS. 2128

Wheat broker John Dupee's 53-room island mansion had nine tiled bathrooms, 18 bedrooms, mosaic floors, Tiffany light fixtures, and gold hardware. Porches had mosaic floors, and in a testament to what can be one era's cause for bragging rights and another era's cause for alarm, "all walls and floors were lined with asbestos."

Edgemoor, the estate of John and Evelyn Winslow Dupee, was achieved when a seven-acre island was dredged and created in 1881. Some of the materials came from dredging that took place at the Woodlands Hotel site on Woodland Lane. Dupee was one of the founders of the Oconomowoc Waterways Company.

In addition to the boathouse, the Dupee estate had guest cottages, servants' quarters, an icehouse, a water tower, and a greenhouse, which in winter protected rare tropical plants that filled jardinieres all along the mansion's terrace.

Dupee's Bay, Oconomowoc, Wis.

Dupee's Bay was formed by a private peninsula located on Buzzard's Point, down Blackhawk Drive. The mansion had silk moire walls, gold leaf ceilings, and gold doorknobs. The 15 bathrooms had bird and flower motifs baked into porcelain wash bowls. A Tiffany chandelier presided over a dining room table that seated 50. John Dupee's den off his 35-foot bedroom contained a stock tickertape machine.

The sweeping entrance to John Dupee's Edgemoor estate and its 2,000 feet of shoreline was not easily rivaled, even in its era of grandeur. A stone wall surrounded the full 28-acre estate. When Dupee sold the property in 1916, it reportedly required five railroad boxcars to move his household possessions to California.

A 30-foot bridge with intricate wrought iron trim led from the mainland to the island estate of John Dupee.

Edgemore Stable, Oconomowoc, Wis.

John Dupee's racehorses were a chief source of satisfaction in a rivalry he single-handedly created with Oconomowoc Lake's Capt. Thomas Parker. Each horse stall in Dupee's stable had a brass nameplate with a horse's name on it. The center of the stable had a velvetlike rug. Dupee was not known for moderation in many things and, when not gambling for a living on wheat futures in Chicago, was widely known to be an "all-night gambler."

John Dupee's stable was constructed of granite, with upper apartments for five English coachmen. Blue ribbon awards, polished tally-ho horns, and silver-embellished harnesses filled display cases and hooks throughout the stable. At one end of the building stood Dupee's five imported carriages.

FLOWER GARDEN, C. E. KOHL, OCONOMOWOC, WIS.

Charles Edward and Caroline Lewis Kohl were theater and nickelodeon moguls from Chicago who visited Oconomowoc, then built a summer home on Lac La Belle in 1892 with these lavish gardens overlooking the lake. While vacationing in Oconomowoc in 1886, Charles had observed lake life while he was out fishing.

Kohl's Cottage, Oconomowoc, Wis. J. A. Herro, Photographer and Pub.

Kohl's Cottage, also known as Brier Cottage, had 45 rooms and duplicated the cottage in which Charles Kohl had spent his childhood in England. Widowed and in declining health during the Great Depression, Caroline was unsuccessful in her attempts to sell the home, which was torn down in 1935.

The sprawling Kohl estate was situated on Lac La Belle between the Shufeldt and Dupee estates. "Good Time" Charlie Kohl, as he was called, was the son of a British ambassador to Puerto Rico. At the age of 18, he ran away from home and joined the circus, later becoming a silent partner in the Ringling Brothers Circus.

C. E. Kohl's Cottage, Oconomowoc, Wis. Mfg. for F. F. Esser & Son

Charles and Caroline Kohl incorporated fanciful touches from their Chicago Orpheum theater enterprise, including the lighted griffins, which guarded the entrance to Kohl's Cottage. The Kohls invested heavily in real estate in the Oconomowoc area, including Draper Hall, where the griffins eventually made their home at its entrance.

John Irvin Beggs purchased Round Island in 1911, and it became known as Beggs Isle, the name it still bears today. Beggs's humble roots as a Harrisburg, Pennsylvania, orphan did not prevent him from prospering, first as the western manager of Edison General Electric in Chicago, then as head of the St. Louis Interurban, and eventually as president of the Milwaukee Electric Railway and Light Company, where he remained at the helm until his death in 1925.

Round Island, subsequently Beggs Isle, also had been known as Kelly Island, where a guest and carriage house stood sentinel at the entrance. John Beggs had a large home built for himself on Beggs Isle to accommodate his lavish style of entertaining. One of the largest of many parties he staged was one celebrating his 75th birthday. Among the more whimsical fixtures on the property was a birdhouse constructed as a replica of the Wisconsin state capitol. It had 144 rooms and weighed 555 pounds.

Lindenmere, built on what had been Round Island by William Shufeldt, was eventually torn down in the 1950s.

William Shufeldt and Mary Kelly, married in 1896, were given Round Island as a wedding gift by his father, Chicago liquor distiller Henry Shufeldt. They built Lindenmere with its impeccably groomed gardens. When William died in 1910, Mary sold what had come to be known as Kelly's Island to John Beggs for a reported $50,000.

Henry Howey Shufeldt prospered greatly as a liquor distiller in Chicago before purchasing Lac La Belle frontage from Joseph Fowler and constructing a four-story Queen Anne villa in 1867. He named it Anchorage.

Anchorage burned to the ground two years after Henry Shufeldt's death in 1906.

Henry Shufeldt's love of beautiful gardens rolling down to Lac La Belle and brimming with rows of roses and a profusion of wildflowers remains a subject of local legend.

Entrance to Schufeldt, Oconomowoc, Wis. Mfg. for F. F. Esser & Son

While the Anchorage estate no longer exists, the road originally marked by this gatehouse still retains the Anchorage name.

Shufeldt Spring, Oconomowoc, Wis.

J. A. Herro, Photographer and Publisher, Oconomowoc, Wis.

Henry Shufeldt discovered a mineral springs on his property sometime in the 1880s. He did not want his private estate to have a commercial enterprise situated on it, so Shufeldt built a pipeline under Lac La Belle to have the water bottled in Oconomowoc and shipped to Chicago for sale.

The Anchorage,
Mrs. H. H. Shufeldt,
Oconomowoc, Wis.

The Henry Shufeldt gardens overlooked Lac La Belle, where his 40-foot steam launch *Princess* became a fixture as it traveled about the lake.

The front entrance to Anchorage, dominated by gardens and a fountain, faced Lac La Belle.

Merchant's Plat just west of downtown Oconomowoc remains a coveted residential neighborhood. Early plantings came from White Elm Nursery in Hartland, which also had about 50 acres of groves of tree stock on Summit Avenue where the middle school stands today.

Originally built in 1860 by David Small, a Pennsylvania-born Quaker and attorney, the Woodlands Hotel was on the south shore of Lac La Belle on what is now Woodland Lane in Merchant's Plat. Small was Waukesha County District Attorney between 1862 and 1869, when he was elected to a 12-year term as a circuit court judge.

The Woodlands Hotel was created when a wetland was dredged, thereby also establishing a readily accessible bathing beach.

By 1915, the Woodlands Hotel had become Woodland Health Farm, treating guests with relaxation and exercise. Brewer Fred Pabst backed the improvements that made Woodland Health Farm a swanky destination known for its fine dining, handball court, baseball, showers, and a treatment known as "electrical baths."

William Perthesius, owner of La Lumiere Resort on Oconomowoc Lake, purchased the Woodlands Hotel site in 1928 and leveled the once prestigious structure. He built the red brick apartment building that still stands today on Woodland Lane.

The Swiss Cottage at the Woodlands Hotel was moved from Woodland Lane to 640 Glenview Avenue, where it remains today in its current restored state.

Lac La Belle summer residents had been sailing for many years before La Belle Yacht Club was formed in 1878, due largely to the efforts of Charles T. Sutton, its vice commodore, and several other charter members.

Charter members of the La Belle Yacht Club included many readily recognizable names: A. J. Rockwell; Henry Schuttler; D. G. Munger; Charles B. Draper; Hugo Lorleberg; William Jones; Walter L. Peck, the first commodore; C. I. Peck; Ferd W. Peck; J. H. Westover; Charles A. Dupee; and William Shufeldt.

City Park in downtown Oconomowoc, as shown in the Victorian era, was a haven of tranquility.

The City Park band shell remains standing today, a symbol of continuity where free concerts by the American Legion Band and other ensembles set the scene for relaxing summer nights.

Generations of Oconomowoc children have learned to swim during lessons offered by the city's parks and recreation department at the beach at City Park.

City Park on Wisconsin Avenue can be seen behind the fountain at Memorial Park next to the former Oconomowoc Public Library site on North Lake Road on Lac La Belle.

The Fowler Lake outlet into Lac La Belle is tranquil despite its proximity to the dam, which feeds it.

The Mill Park Dam carries Fowler Lake water into Lac La Belle and is adjacent to the park also known as Memorial Park.

The first sailing regatta sponsored by the La Belle Yacht Club took place on September 1, 1878, and featured sloops ranging in size from 13 to 28 feet. The race began in front of the yacht club, situated just north of Ferdinand Peck's home. The regatta lasted two hours, 10 minutes, and was a neck-and-neck competition between C. T. Sutton's *Pearl* and Walter L. Peck's *Magic*, the latter of which ultimately came in second.

La Belle Yacht Club's early regatta tradition went well beyond the races themselves. Prizes were awarded, speeches were given, and a ball was held in the parlors of Draper Hall.

Steam yachts were a fixture on the lakes of Oconomowoc for years, including the U.S. Mail boat shown here.

Steam yachts came in all sizes, and many were 40 feet or longer in length.

Caroline Kohl, the daughter of Charles Edward and Caroline Lewis Kohl, married Edward Handlan and lived in this cottage on North Lake Road.

Handlon Cottage, Oconomowoc, Wis. Mfg. for F. F. Esser & Son

Edward and Caroline Handlan's North Lake Road home originally belonged to Harold Peck and has since been razed. It was not far from the original La Belle Yacht Club regatta starting point.

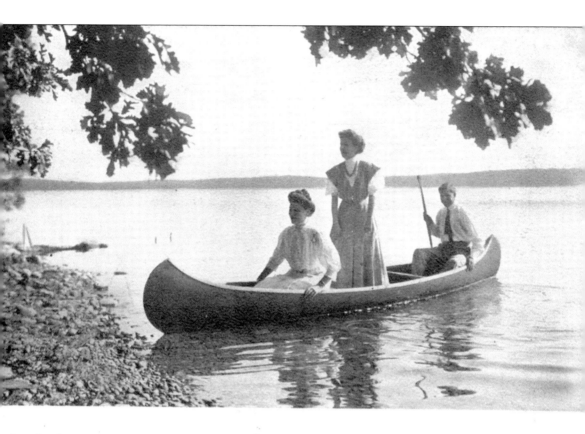

An Outing on Lake La Belle, Oconomowoc, Wis.

This tranquil scene, showing ladies taking their ease on Lac La Belle, belies some of the lively tales that appear to stand the test of time from the homes on Lac La Belle and elsewhere. One of the most well-known families on Lac La Belle, with several branches each ensconced in its own palatial home, was the Peck family. Harold and Anna Peck had four daughters, all under the age of 12, when the incident of the "exploding bathtub" took place. Local lore has it the girls were out walking their pet alligator and catching fireflies the night the wooden bathing fixture caught fire. A maid had filled a lamp with gasoline instead of kerosene and placed it in the tin-lined wooden bathtub in a guest room. The now legendary conflagration ensued and no one was injured. The pet alligator is not the only indicator that the Peck girls themselves were not timid, all four embarking as young women on a trip to London. Josephine married one of Buckingham Palace's Coldstream Guards, and her three sisters settled in Scotland. Haroldine and Anna did not marry but lived in Aberdeenshire, Scotland. Marian married Sir William Farquhar of Breamer, Scotland. All four Peck daughters returned each summer to Lac La Belle until they sold their parents' home to Edward and Caroline Handlan in 1916.

Albert Fowler worked as an agent for Milwaukee founder Solomon Juneau and made it his business to travel to the area now known as Oconomowoc to study the lay of the land in order to be better informed in dealing with government land agents. While it is widely assumed Fowler Lake is named after him, the facts point to the lake being named after Joseph Fowler, who owned land in the area that originally had been acquired by John S. Rockwell following a treaty signed with the United Algonquin Nations. The treaty marked the end of the fur trading era and the beginning of a switch to an agrarian culture. In its native state, Fowler Lake was nearly half tamarack and ash swamp.

TOWNSEND HOUSE

COPELAND TOWNSEND

The Townsend House, the first large first-class hotel in Waukesha County, sat west of Oakwood Avenue, just north of the Norwegian Bridge on Fowler Lake. It was built in 1870 by Copeland Townsend and enlarged four years later to offer 91 elegantly appointed guest rooms. It was then 225 feet long, four stories tall, with room for 500 guests. Townsend spared nothing when it came to amenities, which included hot and cold baths, water in the rooms, gas, electric bells, telegraph service, bowling, billiards, a bar, and evening dancing to a cotillion band in a large ballroom. Each room had an electric fire alarm. An ornamental windmill fueled the gas works and supplied water. Mrs. Potter Palmer, of Chicago's Palmer House hotel, was among the regular guests in a setting that rivaled that stately urban hostelry. The Townsend House was replete with velvet carpets, Greek lace curtains, a concert grand piano, and fine tableware. Mrs. Palmer held the mortgage on Townsend House and ultimately foreclosed on it. The hotel exchanged hands a few times and burned to the ground in 1901 when a paint crew was preparing it to reopen.

Although it had humble origins as a partial swamp, Fowler Lake became home to such businesses as the Fowler Lake Ice Shipping Company, formerly Knickerbocker Ice Company. What remains Fowler Park today was purchased in 1868 by Dr. James Alexander Henshall, a Cincinnati physician and naturalist, who created the nation's first private fish hatchery on his Oconomowoc estate. The estate was known as Enderly and Atterby Cottage, and Henshall built for himself a three-story Gothic chateau with a fireplace in each room and many large plate glass windows.

Fowler Lake from Zion Church, Oconomowoc, Wis.

This view of Fowler Lake from Zion Episcopal Church looks north along the shoreline toward Draper Hall and beyond.

Fowler Lake's Pine Terrace, at 19 rooms, is somewhat modest by comparison with many homes on Lac La Belle and Oconomowoc Lake. It is no less storied, however. Built in 1879 by wealthy wagon makers, the brothers Henry and Peter Schuttler, it was a gift for Henry's bride, Marie Anheuser, of the St. Louis, Missouri, brewery family.

Mon Bijou (My Jewel), as the Schuttler mansion was first known, was a three-story brick and stone home tastefully appointed with rare woods, tiles, glass, and a slate roof. It came with a $50,000 price tag and, over the years, a bit of drama in the form of persistent rumors of hauntings by family ghosts. It exchanged hands several times before being fully restored in the mid-1980s, named Pine Terrace, placed on the National Register of Historic Places, and turned into the bed and breakfast destination it is today.

Mon Bijou had a lawn that rolled down to Fowler Lake in what amounted to a private park and beach. The space today serves as a private park for the residents of condominiums. The new homes sit on a portion of the lawn across the street from the park, at the foot of the hill leading up to the mansion.

Many quiet spots like this still can be found along the shores of Fowler Lake.

This long view of Pine Terrace captures the haunting, and haunted, quality of the mansion during one of its transitional periods.

View of Oconomowoc from across Lake Fowler, Oconomowoc, Wis.

The size of Fowler Lake does not lend it to heavy motorboat traffic, very nearly assuring a timeless tranquility to the body of water.

Two

Four Corners and Beyond
Thriving Hub of Commerce and Industry

Oconomowoc, no "one horse town," was a thriving center of commerce almost from the very beginning. Setting the tone early on was John S. Rockwell. Together with A. W. Hatch, he built a milldam and sawmill at the site of the present Lake Road bridge. A gristmill soon followed. He was the principal backer in construction of the city's first hotel and of several stores. Rockwell was philanthropically inclined in the extreme, chiefly responsible for spreading his beneficence among many denominations to enable them to construct their churches. Upon his death in 1863, Rockwell was buried on the banks of Fowler Lake.

In 1844, the first store, Fay and Collins, opened. For a period of time, it would stand on the land where Draper Hall eventually held sway. The first post office, opened in 1845, was just to the north.

The year 1845 also saw such an influx of eager settlers that a barracks was built to house them. The structure also served as a schoolhouse, hospital, carpenter shop, and blacksmith. Sidewalks came to downtown Oconomowoc in 1865, the year it also became a village, and the city was incorporated a decade later.

By the mid-1860s and into the 1930s, beer brewing was big business in Oconomowoc. Peter and Philip Binzel took a tag-team approach to running Binzel Brewing Company, with Peter at the helm from 1868 to 1912, and Philip taking over in 1920. Reports are that by 1880, the brewery put out an average of 1,200 barrels annually. Popular product lines over the years included Kellermeister, Piccolo, Esquire, Cooney ("brewed with exacting care and extra-aged"), and Extra. The Binzel family also founded the Oconomowoc Canning Company in 1919 as an alternative business in the face of the impending Prohibition.

Across the tracks, an operation with a national profile was up and running by 1918—the Pacific Coast Condensed Milk Company, better known as Carnation, producing thousands of cans of milk each day. The Carnation dairy herd had an equally high profile, with the company having gone on record in 1918 as having paid $106,000 for a prize bull calf. In 1919, it paid $25,000 for a bull to sire the local herd.

Many Oconomowoc businesses have been passed from one generation to the next, with their familiar family names still lingering. Munger Photo Studio on North Main Street, Snyder's Clothing, Wilsey Store, and Welch's Hardware—with the special creak of its wooden floors fondly remembered by many—were downtown Oconomowoc fixtures for decades, names evocative of a bygone era.

Oconomowoc was incorporated as a city in 1875. The first election put Washington W. Collins, a merchant, in the office of mayor. He had opened the city's first store in a log cabin in 1844. Before that, Oconomowoc residents had to make their way to the town of Summit to shop. Collins also raised his voice in song in some of Oconomowoc's first Episcopal church services. Collins Street runs along the northern side of the Main Street Depot, now a restaurant. The thoroughfare was named after Collins, who had yet another dimension to his busy life, serving as the railroad freight agent.

The Mann block, or Mann's Brick Block, on the west side of North Main Street at the intersection with Wisconsin Avenue, was completed in 1872, replacing a red brick building that had been there since 1850. The first structure was the Globe Hotel, then a store, residence, and setting for other businesses. The Mann block contains three separate structures and was built by Curtis Mann, reportedly the wealthiest Waukesha County resident at the time. Pharmacies occupied the corner building for many years.

The Mann block anchored the intersection of Main Street and Wisconsin Avenue for decades, unchanging while even the street names around it changed and the hotel on the corner across the street took on many names and changes to its facade.

Milwaukee Street, Oconomowoc, Wis.

Oconomowoc's "Four Corners" evolved over time. Looking east toward the city hall is what first was known as Milwaukee Street, then became Wisconsin Avenue. Milwaukee Street's Nuisance Pond flooded annually in the spring and often was navigated by canoe or rowboat.

EAST WISCONSIN AVE., OCONOMOWOC, WIS.—33

By the time Milwaukee Street had become East Wisconsin Avenue, the Bank of Oconomowoc replaced Summit Bank on the southeast corner of the Four Corners. The bank stood 115 years before a major remodeling in 1956. Its exterior was refaced in 1974 with Travertine marble imported from Italy. What is now the First Bank of Oconomowoc has been at a new location on West Wisconsin Avenue since 1985. The original bank is now home to office suites. It stands on a site of what initially had been Oconomowoc's first plank house, built by William Quigley in 1839.

E. S. Thompson operated his department store on North Main Street, across from the Mann Block, for 30 years.

Thompson's, Oconomowoc, Wis.

After E. S. Thompson sold his business, it continued under the same name, flags flying. Eventually it became McClellan's five-and-ten store. This postcard served as a Christmas greeting in 1913.

Looking south on North Main Street, Thompson's store is on the left. Across the street, north of the Mann Block, was what became Kellogg Drug Store in 1891. Before that, the site had been donated to the Methodist church by John S. Rockwell. That earlier structure was dedicated in 1850 and used as a church for seven years. Harry Kellogg's drugstore then occupied a new rock-faced limestone building there. It later became Stevens Pharmacy, then the Seasons.

One account has it that it was a point of civic pride that Oconomowoc's dirt thoroughfares were sprayed twice a day to keep down the dust.

The First National Bank building on East Wisconsin Avenue was originally the livery stable for the Jones House Hotel at the northeast corner of Wisconsin Avenue and Main Street. The structure also saw a period of time when it was a rocking-horse factory, the Oconomowoc Wooden Toy Horse Company. The Bedford stone Classical facade was added in the 1920s, and straitlaced banking was under way. Things did not stay tame forever. By 1934, it was discovered that a riot gun stolen from the bank had come into the possession of a John Ridley, whose ultimate intent had been to organize a gang to raid banks.

Across the street from the First National Bank, the La Belle Theater saw a large opening crowd on July 24, 1936. Legend has it that the La Belle was one of the first theaters in the country to screen *The Wizard of Oz*, starring Judy Garland.

Oconomowoc dug out from a blizzard on March 12, 1923.

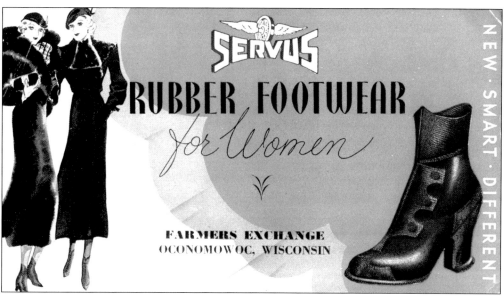

The Farmers Exchange at the intersection of West Wisconsin Avenue and Silver Lake Street was precisely what its name implies. Farmers could bring their produce, meat, dairy, and other commodities to exchange them for durable goods including clothing and footwear.

The Japanese Garden was a place tucked out of the way at the northernmost end of the business block on the east side of North Main Street, overlooking Fowler Lake. Little else is known about the airy porchlike establishment with Japanese lanterns.

For anyone who knew it, it is almost impossible to have enough images, anecdotes, lore, or legend about Draper Hall. Indeed, one advertisement proclaimed, "To Know America, Know Draper Hall." George Peck, of the Chicago real estate dynasty that came to dominate a good portion of North Lake Road for decades, was an early investor in Draper Hall. Clarence Peck soon joined in the enterprise. When George took a bride, Fannie-Jane, they furnished a luxurious suite for their own use. Since they had no children, it was an elaborate and convenient form of summer lake living, which they enjoyed every year until George died in 1897.

DRAPER HALL

Martin Draper managed a tight ship, reported as "too genteel" to contain a barroom. Draper is said to have routinely sported a white flower in the lapel of his frock coat as he presided over the Draper Hall front desk. Among his other distinguishing characteristics was having been a Democrat in a Republican community. He was elected mayor of Oconomowoc in 1876, the year after its incorporation as a city. When Pres. Grover Cleveland came to Oconomowoc in 1885 on a fishing trip, he appointed Draper as postmaster. Meanwhile, across the way from Draper Hall, a men's clubhouse had been constructed; it was where Chicago distillery mogul Henry Shufeldt's products were served and men told their fishing tales, helping spawn Oconomowoc's wide reputation as a great spot for that sport and a generally sporting summer life of leisure.

A Draper Hall guest register contained this entry upon the arrival of a Chicago retail giant: "Mr. and Mrs. Marshall Field and children, nursemaid, valet and personal maid." An April 1927 fire gutted the building, requiring three fire departments to bring the blaze under control. Owner Mrs. C. E. Kohl restored the first two floors after the loss estimated between $50,000 and $75,000.

The City Park's proximity to downtown Oconomowoc always has made it a source of respite for many who work downtown and seek a break in the day. The gazebo no longer exists.

72

For those who do not live on or have direct access to one of Oconomowoc's lakes, City Park occasionally can seem as if it provides a window on "how the other half lives." The first sailboat sailed on Lac La Belle in 1854. It was built by H. P. Lester and named *Kalanthe*.

As dominant a role as it played in Oconomowoc, the Woodlands Hotel was not Judge Daniel Small's only source of influence on the community. Together with John S. Rockwell, Small established the *Oconomowoc Free Press*, hiring Nelson Hawks as its editor. In addition to running Hawks' Inn in Delafield, Hawks also printed an abolitionist newspaper in that community.

Presiding over downtown as it does with its clock tower, once the Oconomowoc City Hall had been placed on the National Register of Historic Places, an award-winning full restoration and expansion was completed in 1983 at a cost of $1,879,394.16.

"Lawdie!" undoubtedly is an expression rarely used in contemporary society. Yet, exclamations over Oconomowoc's continuing growth and change remain a constant. Much of that growth owes to the early efforts of pioneer John S. Rockwell. As president of the Milwaukee-Watertown Railroad, he exerted his influence to have the railroad constructed through Oconomowoc instead of the smaller settlement of Summit. The first train passed through Oconomowoc in December 1854, the same year a train station was built.

C., M. & St. P. Depot, Oconomowoc, Wis.

Central to the growth of Oconomowoc and environs was the arrival of the Chicago, Milwaukee and St. Paul Railroad. Built in 1896, the depot on Collins Street, across from St. Jerome Catholic Church, is said to be the only fieldstone depot still standing in the United States. It was built by Milwaukee Road president Albert Earling and Chicago meatpacker Philip Armour, initially for their personal use so that their guests did not have to disembark at a depot to the east that was adjacent to a stockyard. Passenger service was discontinued in 1972 and the building, now on the National Register of Historic Places, was for a number of years the Old Depot Inn, owned by Joseph Weix Jr. After a period of flux, it is a restaurant again.

C., M. & St. P. Depot, Oconomowoc, Wis.

Big business rolled into Oconomowoc in a big way in October 1914 when the nationally prominent Carnation Company installed its Western Division office at what is now the intersection of Concord Road and Second Street, land that was attractive primarily due to its location immediately next to the railroad tracks. Roy O. Henszey, chief engineer for the company, designed not only the firm's buildings but several homes for its executives, primarily in the Glenview Avenue area on Lac La Belle.

Carnation Milk Products Company was a leading Oconomowoc employer for decades. The Oconomowoc plant was the largest in a chain of six factories around the country, with an evaporating plant, can factory, machine shop, central laboratory, and general office. High standards were ensured when the company lured into its employ professor A. C. Oosterhuis, a Holstein-Friesian scholar on the University of Wisconsin-Madison faculty, to operate its new Dairy Extension Division. Farmers selling their milk products to Carnation were required to adhere to a two-page checklist of regulations.

Carnation Company was a good corporate citizen, maintaining attractive landscaping locally and, in 1929, shipping 4,800 cans of milk to malnourished children in Puerto Rico. The new general office building constructed in 1923 featured such innovative technology as air conditioning, indirect lighting, and sound proofing.

GENERAL OFFICES
CARNATION MILK PRODUCTS CO.
CARNATION BUILDING
OCONOMOWOC, WIS.

The general office complex on the south corner of the intersection of Concord Road and South Street was operated between 1951 and 1974 by the U.S. Treasury Department as general office space. In 1977, it was transformed into the low-income housing development Hickory View Commons, which is its present use. Administrative and production changes as early as 1948 affected Carnation's longevity in Oconomowoc. One dramatic change was the transfer of executive and general offices to a new nine-story office building in Los Angeles. Instant products such as the nondairy coffee creamer Coffee-mate and Instant Breakfast helped Carnation reconstitute itself until it sold the entire company to Nestle in 1985. For years, however, it was possible to assess the scent of the neighborhood of the Oconomowoc plant and know whether chocolate, vanilla, or strawberry Instant Breakfast was on the production line. The same was true in the Summit Avenue neighborhood where Brownberry Ovens infused it with appetizing aromas of croutons and raisin-cinnamon bread.

In the left foreground stands the Jones House—soon to become the Majestic Hotel, so named in 1916 when it was purchased by Draper Hall owner Mrs. C. E. Kohl. It already had been at the center of a good deal of Oconomowoc's social whirl and the tradition was to continue for years to come. First, there had been the La Belle House, a tasteful white frame hotel that opened in 1850. It was destroyed by fire in 1875, the third such major blaze to destroy a large segment of the downtown area. That third episode sparked the founding of the volunteer fire department one day after the fire.

JONES HOUSE, OCONOMOWOC, WIS. HAND COLORED WORK, A. C. KROPP CO., MILWAUKEE, NO. 2259

Before the Jones House was built on the northeast corner of what now are Wisconsin Avenue and Main Street, La Belle House opened in 1850, but was destroyed by fire in 1875, along with other downtown establishments.

Looking north on North Main Street, the Jones House in the right foreground reigns over the passing scene. Built in 1887, it was the work of architect W. H. Parker of La Crosse. The Jones House was the first year-round resort in the area, and its grand opening, with more than 400 people in attendance, was depicted as "the grandest social event in the history of Oconomowoc." The first floor, with 14-foot high ceilings and elaborate oak woodwork, was occupied by a dining room that seated 120. There also were a reception area, reading room, kitchen, and a "Ladies Ordinary," a semi-private dining room for 40. The second floor had 16 rooms with 13-foot ceilings, and the third floor's 18 rooms had 12-foot ceilings. A barbershop and billiards room were in the basement. A local band played from a second-floor wrap-around balcony for street dances.

Cliches such as "If these walls could talk" came into being for a reason. The seemingly staid reception room of the Majestic Hotel was known as a gathering place for Midwest millionaires who knew how to circumvent the Prohibition-era laws against alcohol consumption. Dapper attire practically required a walking cane. In those days, the canes were hollow and doubled as liquor flasks while the socially prominent sipped from them with impunity in the safe confines of the Majestic, to which local law enforcement turned a blind eye.

Dining at the Majestic was majestic in every way. It was widely renowned for its roast Watertown goose with apple stuffing, oyster cocktails, prime rib, chicken, fritters, and desserts. Special events frequently called for special bills of fare and souvenir menus. The Majestic, along with Draper Hall, for many years was the scene for regular bridge luncheons that would draw as many as 50 women. One book that recorded the get-togethers lists everything from time and date to menu, prizes and their winners, all participants, and random remarks on who wore what and who sat next to whom.

The Towne Hotel was the last incarnation of the various hotel names and identities of the single structure that had anchored the intersection of the city's two main thoroughfares for more than a century. The building was condemned and razed in 1975. The Village Green now occupies the site.

Three

WARMTH AND NOBILITY
STATELY INSTITUTIONS AND
CIVIC DEDICATION

Oconomowoc was founded by sturdy, civic-minded pioneers who set a tone of public-spiritedness from the earliest years. Schools and churches throughout the area have long stood sentinel as evidence of successive generations' sense of obligation to insure that there would always be men and women who naturally served as pillars of the community.

Home schooling was the norm throughout Wisconsin until statehood in 1848, when one-room wooden schoolhouses such as one in the town of Summit began to spring up, eventually giving way to those constructed of stone and brick. The town of Summit in 1911 once again became a hotbed of innovation in public education when Fred and Ida Pabst donated the land and funds to construct Summit School, which, albeit vacant, still stands today. From the moment it opened, "the Pabst school," as it was popularly called, was regarded as one of Waukesha County's top flight public schools.

The solid red brick Lincoln School on South Street, constructed in 1902, served as a high school, subsequently a middle school. It was demolished in 1965 but remains a fixture in the memories of many longtime Oconomowoc residents.

The next new high school built in 1923 continues to serve as Oconomowoc's middle school. When the cornerstone was laid in 1922, a copper box "time capsule" was encased in it, containing official photographs, coins, newspapers, clothing patterns, and contracts for the building.

Both the Roman Catholic and Episcopal denominations made significant and lasting contributions to the Oconomowoc area. St. Jerome Catholic grade school opened to 162 students in 1926. The building now serves as the anchor to a recently opened age 55-plus apartment complex on South Main Street.

The Redemptorist fathers operated the former Springbank resort, originally the private residence of Col. Thomas Parker, as a boys' camp, beginning in 1913. The property became the Cistercian monastery in 1928 and abbey in 1963, ultimately a retreat destination for church hierarchy and the retirement residence of former Milwaukee Archbishop William Cousins.

Equally venerated and still producing Episcopal priests to this day is Nashotah Mission on Upper Nashotah Lake, established in 1841. Nashotah Mission first opened in 1844 to educate students for the priesthood and as a mission church reaching out to Native Americans and pioneers alike. That took the missionaries into a wide range of settings to deliver the Gospel, from schools to cottages, farmhouses, and saloons.

Perhaps it is the timeless timeliness of Oconomowoc's natural beauty that inspires and draws out the best in all who contribute to the community in any way. The immediate Oconomowoc area is heavily influenced by the presence of Increase Lapham, a Quaker and founder of Waukesha's Carroll College. Lapham brought his family to Oconomowoc Lake in 1872. In addition to Carroll College, Lapham also started the U.S. Weather Bureau. Lapham Peak in Delafield, which he determined was the highest point in Waukesha County, is named in his honor. Lapham was an avid collector of relics and artifacts, some of which continue to be featured in Wisconsin museums. However, many items were lost in the University of Wisconsin-Madison Science Hall fire of 1875. Lapham passed away in his rowboat on Oconomowoc Lake that same year. His daughter Julia went on to play a key role in establishing the Oconomowoc Public Library. Like her father, she took an avid interest in history and was active in more than one historical society.

George Bowman Ferry, the architect who designed the Oconomowoc City Hall, was regarded as one of the top three in Milwaukee during the late 19th century. When the city hall was constructed in 1886, the area's signature cream colored bricks, which continue to give the landmark its luster today, were hauled to the site from a brickyard some 20 miles away. Its architectural significance draws from several features such as the Gothic Revival style, recessed arches, gabled roof, second-story proscenium arch, 18 orange and turquoise stained-glass windows, limestone foundation, clock tower, and steeple.

The Oconomowoc City Hall was the site for all municipal activity, and its auditorium also was the largest and best venue for a variety of other events including concerts, dances, public meetings, school plays, and graduation ceremonies. The room now is the city council chambers. With a 1980 threat that the city hall would fall under the wrecking ball, a successful effort was made to have it placed on the National Register of Historic Places, followed by a full restoration. In this Victorian-period illustration, a horse trough can be seen in the right center foreground.

Few structures in Oconomowoc have been more venerated during their day and perhaps even more deeply mourned in their demolition than the Oconomowoc Public Library complex captured in this early-20th-century photograph from a vantage point east of the Fowler Lake boat launch. It was the oldest brick building in Oconomowoc and was razed in 1988 after a new library was built and efforts to save the edifice failed even though documentation had been on hand since 1977 sufficient enough to place it on the National Register of Historic Places. The group of buildings originally was known as Downtown, the first section constructed in 1854 with John S. Rockwell taking the lead on the project, along with his business associate Alex Randall, who would go on to serve as Wisconsin's governor during the Civil War. The building also was Randall's election campaign headquarters. Other uses for various sections included a bottling factory for "Oconomowoc Natural Spring Water" in the southernmost section and the local telephone company, which vacated the northern third of the complex in 1954.

Before it became the library, the series of buildings housed the city's first hardware store and a group called Loiterers' Club. Large windows, a fireplace, and open porches created the base of operations for lake excursions. The Summit Bank made its home there until 1870 as did the village hall, then the city hall, when Oconomowoc incorporated in 1875. Firefighting apparatus and the city's fire bell were kept there. A blacksmith shop on the premises eventually gave way to the Von Munger photography studio, which produced many postcard images of Oconomowoc. The Oconomowoc Library Association purchased the center building in 1901, at first using only the street level for its operations. The upper floor, known as Library Hall, was the site for plays, concerts, and basketball games. Over time, the library acquired the buildings to the south and north. From left to right, they eventually became the children's room; adult services, circulation and reference; and a periodical room. A museum-like accumulation of materials was on display in the upper floor and was a regular attraction for school students' field trips. A pair of well-traveled wrought iron griffins graced the library's main entrance for many years after Draper Hall was razed. The griffins had been placed in front of Draper Hall by Mrs. C. E. Kohl when she purchased the landmark resort in 1922. Prior to that, they had stood at the front entrance to her home, Kohl's Cottage, on Lac La Belle. The Kohls brought the griffins to Oconomowoc as a memento of their Chicago theater.

Clergymen and others helped get the ball rolling for the construction of Oconomowoc Memorial Hospital. It was through the generosity of a $100,000 gift by the Fred Pabst family that 11 acres on Summit Avenue were purchased. Five hundred people reportedly turned out for the ceremony when the cornerstone was laid after ground was broken in 1952. It was reported that every service club, fraternal organization, and church in a seven-mile radius embarked on fund-raising projects for the hospital. The hospital was enlarged again in 1967 and, in 1975, the Fred Pabst Foundation provided $1 million for yet another expansion.

The clubhouse of the American Legion Post No. 91 enjoys a prime location on Lac La Belle, southwest of the Mill Park dam on North Main Street.

Zion Episcopal Church, seen from Fowler Lake, was constructed in 1889 on a wooded peninsula that juts out into the lake. The land was donated by John S. Rockwell, who also contributed much of the costs of constructing the first church edifice. The congregation was founded in 1841 and first met in a log schoolhouse, served by Rev. Lemuel Hull, who conducted services once a month, traveling from St. Paul's in Milwaukee. During the warm weather months, Reverend Hull traveled 30 miles one way on foot to the mission outpost. Regular services began in August 1846.

Zion's existing limestone Romanesque building replaced an earlier brick church, which was demolished after 36 years due to the discovery of a structural defect. A stunning addition to the church came with the June 1924 installation of a stained-glass window honoring the late Thomas and Emma Marston, who had been instrumental in the church's construction. For a period of time, until the new city hall was built, the city's fire bell was installed in the Zion Church tower.

The First Congregational Church on South Church Street, erected in 1854, was an ideal example of New England architecture. The congregation formed in 1841, with 17 women and 14 men. Theodore Worthington, an early settler who is said to have donated the land on South Street for Lincoln School, also contributed the land for the modest edifice. Worthington's son Frank was the president of the Women's Christian Temperance Union. Construction of the church required elaborate measures, including an oxen team hauling timbers from Fond du Lac.

The First Church of Christ, Scientist, Oconomowoc, was built on Roosevelt Avenue in 1956. In the nearly 50 years prior to that, Christian Scientists in the area had held their services in the library, homes, and other gathering places.

Before this elaborate sanctuary was constructed in 1889, St. Jerome Catholic Church was a missionary outpost of St. Catherine Church in Mapleton. The first St. Jerome structure was a simple painted frame building constructed in 1860 on land donated by John S. Rockwell, who made a practice of helping various denominations establish themselves. There were 40 families in the parish when it was organized in 1847. The current cream brick Gothic edifice rests on a limestone foundation. A parish hall was installed during an excavation project in the 1940s, and stained-glass windows depicting various saints of the Catholic Church were installed in 1955, each sponsored by or memorializing an individual or family.

St. Jerome Catholic School opened in 1927 in the original red brick structure. There were 162 students, taught by the School Sisters of Notre Dame of Elm Grove, who presided over the school's education into the 1970s, at which time the faculty evolved largely into laity. One-story additions were added to the southwest of the original building in the 1960s, as was a gymnasium to the north. Early in 2006, the original building began a new chapter as anchor to a new 55-plus apartment complex.

St. Paul's Evangelical Lutheran Church on the shore of Fowler Lake, as it stands today, was dedicated in March 1917. The church was organized in 1865 with a handful of charter members.

St. Matthew's Evangelical Lutheran Church on West Wisconsin Avenue was constructed in 1952 for a congregation that had been established since 1922.

Dr. Martin Luther Church, one block south of St. Jerome Catholic Church on South Main Street, was established by 21 families in October 1896. The current building was constructed in 1957.

Lutherland, the former Dupee estate, established a retirement living legacy for Oconomowoc that continues to expand and evolve to this day. In 1939, Judge Alvin Brendemuehl, along with several civic leaders and clergymen, formed the Lutheran Homes Society of Wisconsin and purchased the Dupee estate, which already had been converted into a private hospital. Lutherland operated as a nursing home until 1942, when it was sold to the Augustinian order of Catholic priests for use as a school. The main mansion was destroyed by a fire on Christmas 1942. The Augustinians then were given the 40-room Gus Pabst home built in 1927 on Upper Genesee Lake. When Marjorie Ward Baker died in 1959, her will instructed that her North Lake Road estate, Knollward, be given to the city for use as a library and community center. The city rejected the gift because of the annual maintenance cost and loss of tax revenue. Knollward was donated to Lutheran Homes of Oconomowoc, which operated it as a nursing home until it was sold to private owners who have restored its interior and grounds. Montgomery Ward's real estate holdings and the Lutheran Homes of Oconomowoc have a rich and textured mutual heritage. In addition to the period of time when Knollward served as a nursing home operated by Lutheran Homes of Oconomowoc, the present-day Shorehaven complex sits partially on land that was part of Montgomery Ward's own estate built in 1890 on a 300-acre farm on the west side of Lac La Belle. Ward raised horses and raced them on a track on the estate. In the course of construction of new buildings in the early 1960s, the former Dupee estate mansion was dismantled, Lutherland became known as Shorehaven, and, in 1961, Knollward began its durable tenure as a retirement residence for individuals who did not require nursing care.

M. H. Tichenor's Cottage, Oconomowoc, Wis.

J. A. Herro, Photographer and Publisher, Oconomowoc, Wis.

Myron Tichenor could not have foreseen what would become of his comparatively modest Colonial home on Lac La Belle's northern shore over the years. When attorney James Herron Eckles purchased it in 1903, he renovated it into a lavish and sprawling estate called Longview. Eckles died in 1907. In 1910, the Redomptorist fathers bought the 28-acre property and mansion, launching an era when the influence of the missionaries trained at the seminary that they established there would be felt around the world.

J. H. Eckel's Cottage, Oconomowoc, Wis.

J. A. Herro, Photographer and Publisher, Oconomowoc, Wis.

James Eckles's Longview was a 28-room mansion with 16 bedrooms and a large ballroom that saw elaborate entertaining. A terraced lawn ran down to the lakeshore's 2,000 feet of frontage. Eckles served four years as chief comptroller of the U.S. Treasury and was president of the Commercial Bank of Chicago at his death at age 49.

Once the Redemptorist fathers purchased James Eckles's estate, they quickly broke ground in July 1910 and added a new wing to the original building. A spacious porch ran along the length of the complex.

Among the multitude of changes made to Longview by the Redemptorist fathers was a reconfiguring of the mansion's living room into a recreation room with adjoining library.

The enormous ballroom at Longview was remodeled into a chapel by the Redemptorist fathers. The ballroom's band alcove became the chapel's choir loft.

As the years rolled by and the Redemptorist order flourished, the terraced lawns gave way when a new chapel wing was constructed in 1924. The original mansion also was razed. The need for another addition was seen in 1944, and it opened in 1948.

Although their growing ranks caused the Redemptorist fathers to significantly reconfigure and ultimately demolish the original private residences of Myron Tichenor and James Eckles, the grounds were cultivated as a haven of tranquility with numerous secluded areas for rest and reflection.

This grotto at the Redemptorist seminary on Lac La Belle appears illuminated naturally and supernaturally. The Redemptorists' hilltop sanctuary has been replaced by Monastery Hills, an upscale housing development where the 36 homes, some on the lake and some with lake views, are required to sit on lots of at least 30,000 square feet in dimension.

The influence locally of the Redemptorist fathers was not restricted to Lac La Belle. Their Perpetual Help Retreat House on Crooked Lake south of Delafield was founded in the early 1960s and is open year-round to retreat groups of various denominations. The main building has 60 furnished rooms, all with private baths. Formerly the Otto Falk estate, Barkmoor, established in 1917, it also served for a period of time as the Timber Trails Lodge for children with disabilities. Falk was president of Allis Chalmers Company in Milwaukee and a gentleman keeper of Toggenburg goats in his free time.

St. John Chrysostom Episcopal Church, "the little red church on the hill" in Delafield, was consecrated on May 20, 1856, by Right Reverend James Kemper, three years before he was installed as that denomination's first bishop in Wisconsin. The newly ordained James DeKoven, now Blessed James DeKoven, was the church's first rector until 1859, when he became warden of Racine College.

NASHOTAH MISSION FROM THE LAKE.

Nashotah Mission took its place in Oconomowoc area history in 1841 when Episcopal Bishop Jackson Kemper sent three of his young students to the territory of Wisconsin, each with $250 to his name, to found a mission. It quickly became the Nashotah House seminary, a campus of more than 350 acres and numerous historic buildings that continues to produce Episcopal clergy.

CHAPEL OF ST. MARY THE VIRGIN – NASHOTAH MISSION – NASHOTAH, WIS. 14

The Chapel of Mary the Virgin is in many ways the heart of the Nashotah House seminary. In addition to its ornate interior, the chapel's yard is home to Michael, a one-ton bell that calls the community to prayer. Thrice daily—before morning and evening prayer, and at noon—a member of the junior class rings the traditional Angelus prayer, bringing all members of the community to a pause for prayer while Michael's tones are heard throughout the campus.

Alice Sabine Hall at Nashotah House was constructed in 1893. It also is known as the Cloister and provides a walkway between the Chapel of Mary the Virgin and classrooms, faculty offices, and single student housing.

St. John's Military Academy in Delafield was founded in 1884 by Dr. Sydney T. Smythe. Its motto is Work Hard, Play Hard, Pray Hard. Several years ago, it merged with Northwestern Military Academy, which had been located on the south shore of Geneva Lake. Today the coeducational school is known as St. John's Northwestern Military Academy.

The former National Guard armory is now home to the Oconomowoc Historical Society and has been named to the National Register of Historic Places. It is a repository of closely held and guarded archival materials. The former armory itself represents a significant chapter in area history thanks to its heyday as home to Company G, the 32nd Red Arrow Division of the National Guard and the legendary 127th Infantry Division of the U.S. Army, subject of its own lengthy historical chronicle.

Oconomowoc soldiers of the 127th Infantry Division of the U.S. Army make their way down Wisconsin Avenue in a victory march following World War I. Many of them also served for long periods of time in Company G, the 32nd Red Arrow Division of the National Guard.

Four

OCONOMOWOC LAKE
A STUDY IN GRANDEUR

Grandeur has gone hand in hand with Oconomowoc Lake for more than a century and a half.

Early settler George P. Gifford and his family helped set the salons, soirees, and sailing in motion when they built a stunning home on the lake in 1858, then opened it to the public as a resort in 1875.

The railroad, which arrived in 1854, made it easy for wealthy patrons to make their way to what was rapidly becoming their primary playground. Carriages brought them from Gifford Station in the short ride to their hotel, which boasted more than 100 acres of forest and meadows and some of the most spectacular shoreline on the lake.

When Gifford's first opened to the public, it was for a four-month summer season, and records show the town of Summit charged the establishment $8.33 for a liquor license. By 1895, the resort had grown and the fee was $100.

The wealthy Armour meatpacking family and others were paying $2.50 per day to stay there, or between $10 and $14 per week. In its heyday, Gifford's grew to accommodate 150, then 350 guests.

Chinese lanterns lined a pavilion, and an orchestra played on the lawn on many an evening. The hotel's boats transported guests around the lake for scenic excursions and water sports. Wiling away the time, resort-goers could take their ease while playing billiards and croquet, dancing, and bowling. It was not all idle pleasure, however. Improving one's mind through membership in the Summer School of Philosophy was regarded as the sign of a true sophisticate.

Philip Armour was among the first of many staying at Gifford's who made the decision to purchase land and build his own summer cottage on Oconomowoc Lake, thereby launching an era. The automobile made it that much easier for families to create and motor to their own personal summer retreat compounds.

Soon Gifford's Hotel, or Villa Gifford as it also was called, was no longer the popular destination with a full guest register that it once had been. Attempts to make it a year-round getaway, including such improvements as a toboggan slide, steam heat, and fireplaces, did not help stem the tide of decline. By 1910, the property was sold and subdivided, leaving only a few of the original buildings, which became private residences.

Farther along the northern shoreline, Chicago shipping tycoon Capt. Thomas Parker and his wife Clara purchased 1,000 feet of lake frontage, representing more than 200 acres, which incorporated the McConnell estate. The storied Parker Place had many lives to come.

These lions no longer stand guard at Danforth Lodge, also known as the Valentine estate, but the brick wall surrounding the property remains. The mansion was razed in the early 1950s after serving a stint as Danforth Lodge Military Academy. Philip Armour gave this estate to his son Philip Jr. and bride May as a wedding gift. When she was widowed, May is said to have delved ever more deeply into designing and cultivating the already extensive tiered gardens. In two years' time, May married Armour Company executive Patrick Valentine and the property generally is known today as "the old Valentine estate." May Valentine, who sold the property in 1941, was widowed for a second time in 1916 and divided her time between Oconomowoc Lake and Chicago until she was well advanced in years. May Valentine died at age 95, leaving a reputation for generosity not only to all those she employed but in being instrumental in establishing the Oconomowoc Public Library.

Philip Armour Sr., president of the Armour Meat Packing Company, acquired between 160 and 180 acres of prime Oconomowoc Lake real estate in 1887. Some accounts say the parcel on the lake's northwest corner sold for $25,000 and others report a $12,000 price tag. The land stretched along Beach Road between what are now Valentine and Armour Roads.

Philip Armour Jr. and his bride May were given his father's estate as a wedding gift. "Passion" is not a cliché when speaking of May's love for her gardens.

Danforth Lodge anchored a neighborhood that Philip Armour Sr. populated with a few of his friends, including his best friend, railroad tycoon Albert Earling. Armour gave Earling 20 acres on the south side of Armour Road, a thoroughfare leading from the estate into the city of Oconomowoc. Ease of travel was further established when Earling gifted Armour with a railroad sidecar area next to Danforth Lodge, making travel all the more convenient. Earling's home still stands high on its hill overlooking the lake today.

Philip Armour Jr. died at age 31 in 1900, leaving May a widow at 29. Two years later, she married Armour Company executive Patrick Valentine. They lavished considerable sums of money on the 52-room home and grounds. Among the features was a double fireplace made of Cannes stone with a huge moose head over the mantle. A new family room was paneled in curly ash. Leaded windows prevailed throughout, many furnishings were imported from European castles, and a screened veranda added to the sweeping grandeur.

May Armour contracted with Oconomowoc Waterways Company in 1901 for construction and maintenance of a canal and system of locks named Danforth Locks. It was part of a system that helped carry mail and passenger boats between Oconomowoc Lake and La Belle and Fowler Lakes in downtown Oconomowoc. The lock keeper's home is shown here.

The boathouse at Danforth Lodge stood as a symbol of the relaxation that Patrick and May Valentine craved as a respite from the business and social whirl of Chicago. Feeding the ducks that swam through the boathouse's archway was a frequent pastime.

When she was widowed the first time, it is said that May Armour Valentine immersed herself in gardening. Lilies and violets were among her favorite flowers.

Although the Valentines employed more than 30 local residents as gardeners and household staff, May Valentine had a heavy hand in the management of her greenhouses where, in addition to lilies and violets, she grew more than 40 varieties of chrysanthemums and a wide variety of grapevines. William Rockefeller is said to have pronounced the Valentine gardens finer than many he had visited on the East Coast. Greenhouses behind the scenes certainly must have done their share to help cultivate that reputation.

The Armour Bridge connected to an interior island in front of the estate, aptly and whimsically named "Cooney Island" after the nickname for the city of Oconomowoc. The cozy interior island today is home to a single-family dwelling across Beach Road from what remains of the Armour and Valentine estate.

COACH HOUSE SUMMER THEATRE, OCONOMOWOC, WIS.

May Valentine donated some 20 carriages from her estate to the Ford Museum in Michigan sometime during the 1920s. She transformed the empty coach house into a theater for summer stock productions, borrowing from a 1930s East Coast trend. The theater was outfitted with lights, a stage, dressing rooms, and seating for 200 theatergoers.

Other than the paving of what once was a dirt road, little of the character of the stretch of Beach Road south of Valentine Road on Oconomowoc Lake has changed over the years. There was some controversy in a bygone era, however, when Philip Armour donated Armour Road to the city so that city dwellers could travel to his island to picnic on Sundays. He then installed a locked gate across the public lakefront road and it took a petition from 500 resort guests to have the gate removed and access restored to the scenic carriage drive.

Villa Gifford was built in 1858 by George P. Gifford. In 1875, the Giffords turned their summer home into a resort, which they opened to the public. That opened an era when many wealthy industrialists summered there, ultimately taking to the area in such a way that they built their own "cottages." At the time of its sale in 1910 and subsequent subdivision, the resort could accommodate 350 guests.

The highly exclusive Oconomowoc Lake Club was established in 1890, restricting membership to only 35 families. The club held its functions at Gifford Resort for nearly 20 years before this clubhouse opened for its first season in 1910. Patrick Valentine, the club's first commodore, was the chief financial backer of the new building. He spared nothing, hiring as the club's first chef a man whose previous employer had been the White House. Flowers from the Valentine estate graced the clubhouse, and the Valentines annually commissioned their family organist, Percy de Coster, to produce a musical for club members. Opulent though its events were, the club's members possessed a rarefied and dignified sense of taste, closing its doors throughout the Great Depression in respect for the nation's plight. The club reopened in 1934.

The Oconomowoc Lake clubhouse has had its vulnerable moments. Thieves with a regional turf for purveying their booty stole a vast quantity of silver monogrammed OLC in 1910 and attempted to peddle it in Milwaukee. They were arrested and each spent two years in the state prison in Waupun, reflecting on their brush with the high life on Oconomowoc Lake. Fire destroyed the clubhouse in 1994. It has been replaced with a new structure.

A 1937 donation of land by William Chester allowed for construction of tennis courts up the hill from the clubhouse. They remain popular to this day. The following year, Robert and Marjorie Ward Baker donated new white wicker furniture covered in blue leather and several other spectacular decorating touches, all lost in the 1994 fire.

A windmill to generate power, primary or supplementary, is just one more signal of the thoroughness Oconomowoc Lake residents brought to creating their summer havens.

Julia Lapham, daughter of Carroll College founder Increase Lapham, sold her father's 100-acre Minnewoc, with prime Oconomowoc Lake frontage, to George Bullen in 1888. Chicago malt tycoon Bullen had met Lenore Nixon at Gifford's resort. Their marriage was also a love affair with Oconomowoc Lake. Bullen hired local estate builder Louis J. Flotow to build what, by anyone's definition, was a castle. The project took two years. The gate lodge was one of several ancillary structures, which included a coach house, gardener's house, water tower with a wound clock, and Lapham's steam-heated greenhouses where flowers and food were grown year-round. The entire estate was enclosed by a large stone wall and its clock's chimes could be heard across the lake.

Fred Pabst Residence, Oconomowoc Lake.

Fred Pabst and his wife Ida moved to Oconomowoc Lake in 1906, building their 27-room estate called Woodbine. Over the years, Fred's world-famous dairy and crop farm grew to about 2,000 acres. Although low-key in their socializing, the Pabsts were warm and philanthropic people. Being low-key did not prevent the film location scouts of the day from finding them, however. In November 1914, the Embassy Film Company of Chicago filmed portions of a movie at the Pabst farm. The film, *Mischievous Mary,* was given a screening at Oconomowoc's Palace Theater. What can only be described as the Pabst Dynasty flourished and expanded both in Milwaukee and around Oconomowoc Lake, this despite the Prohibition years. The brewery weathered Prohibition by switching to production of "near-beer" and malt syrup. For the most part, Capt. Fred Pabst Sr.'s sons Fred and Gus maintained separate but complementary enterprises, with Gus at the brewery's helm and Fred thriving in a diverse farming operation but helping with the brewery during Prohibition. Between 1906 and 1920, the Pabst dairy farm in the town of Summit swelled to 1,400 acres. Its Holstein herd gained worldwide renown. Pabst cheeses during those years had their strongest rivals in Borden and Kraft products. The Kraft product Velveeta comes from Pabst-ette, a process that Kraft purchased in 1933. Show and hunting horses as well as wildlife and American Indian mound preservation rounded out the Pabst farming operation.

This tranquil scene looking toward Oconomowoc Lake from the main LaLumiere lodge portrays one aspect of life at the resort, which changed hands a few times. Some versions of its history say one set of its owners named the popular destination after Fr. Stansilaus P. LaLumiere, a priest at Gesu Church in Milwaukee. In the early 1900s, LaLumiere resort was one of Oconomowoc's most popular nightspots. Reports are that activity remained high during the Prohibition era, with news accounts of a federal sting operation in 1921 and the case being thrown out of court due to shaky evidence. There also are tales of slot machines being tossed in the channel shown in this postcard during those same raids. LaLumiere at one point had its own garden, chickens, and cows, providing the additional reputation of superb cuisine. Later known as the Lakeshore Supper Club, the lodge was destroyed by fire in 1967.

If it is true that every picture tells a story, then sweeping historical novels could be written about some of the inhabitants of the George R. Peck mansion that still stands today on West Beach Road. Peck, a general counsel for the Chicago, Milwaukee and St. Paul Railroad and then founder of his own Milwaukee law firm, rose to the rank of president of the American Bar Association in 1906. He attended Wisconsin's Milton College, now of a bygone era, and received several master's degrees from Marquette University and Northwestern University and was an infantry captain in the Civil War. His heirs sold the home to Miller Brewing Company heir Frederick C. Miller. Among his many distinctive acts, Miller purchased Draper Hall on Fowler Lake and donated it to the Sisters of St. Dominic, when it then became known as St. Ann's, a nursing home for women. Miller and his son Fred Jr. were killed when the private plane he was flying home from the brewery crashed on takeoff in 1954.

Waldheim Park Sanatorium was the brainchild of Philip Armour, who had been treated at a German spa for his neuralgia and wanted to replicate such a retreat on Oconomowoc Lake. The main building was a large four-story structure designed in the Queen Anne style of architecture. There was a large library stocked with current novels, an exercise room, a solarium, and a game room featuring billiards and bowling.

The main bridge at Waldheim brought traffic over the Oconomowoc River. The bridge was razed in 1925.

Waldheim's fresh air cabins were part of the spa's philosophy of natural cures developed and prescribed by Dr. John Henry Voje, brought to Oconomowoc from Vienna by Philip Armour to run the facility. The staff included physicians, a matron, a bath master, nurses, and masseurs. There also was a nursing school. Treatments revolved around education and suggestion and such regimes as hydrotherapy, electric sand, and carbonic acid baths. Medicine and drugs were reserved for extreme cases.

Dr. John Henry Voje lived in one of the cottages constructed on Waldheim's island. While Dr. Voje had a reputation for an authoritarian manner, his European mannerisms and the care they received over the years caused many area residents to recall him fondly.

The Oconomowoc River has inspired many a photographer over the years.

Dixon's Cottage, Oconomowoc, Wis. Mfg. for F. F. Esser & Son

Scottish-born Arthur Dixon had strong ties to his neighbors Philip Armour Sr. and Albert Earling. Dixon was a wagon manufacturer whose vehicles were used to haul Armour's products to Earling's railroad. So it was only fitting that Dixon acquired 160 acres and 1,000 feet of shoreline not far from the two, farther down Beach Road. Thirteen bedrooms and 10 bathrooms were required to accommodate the Dixons and their 12 children in the oft-expanded mansion.

Dr. Arthur Rogers and his wife Theresa purchased the former Mason Hill estate in 1907, thereby allowing him to pursue his dream of establishing a hospital to care for individuals "suffering from nervous disorders." He espoused a regimen of bathing, which he believed to be central to the healing process. Patients were prescribed hydrotherapeutic schedules regulated in temperature control on an individual basis, ranging from steam to ice water. The water supply reportedly had healing properties similar to nearby Waukesha Springs, bringing Rogers' Oconomowoc Health Resort wide acclaim. The original building still stands, serving patients in need of contemporary treatment for substance abuse and eating disorders.

Big Ben Alarm Company owner Frank W. Matthiesen purchased 14 acres on the south end of Hewitt's Point on Oconomowoc Lake in 1916. He and his wife Marilyn arranged to have built a Spanish-style villa that was at the end of the entrance captured on this postcard.

While it would be folly to choose any one edifice on Oconomowoc Lake as the "most storied," it can easily be said that the Parker Mansion (also Springbank Hotel, a Catholic boys' camp, a Cistercian Monastery, and an archbishop's retirement residence) had a rather textured history. Chicago shipping tycoon Capt. Thomas Parker and his wife Clara purchased 1,000 feet of frontage and more than 200 acres on Oconomowoc Lake's north shore in 1870. They erected this three-story, 30-room brick mansion. Seven marble fireplaces and imported woods added no small amount of solidity. Highly unusual features for Oconomowoc at the time included hot and cold running water and steam-powered electricity.

Bathing Beach, Spring Bank, Oconomowoc Lake, Wis.

When Capt. Thomas Parker reigned supreme over Parker Place, he brought a 40-ton yacht, *The Waubun*, to his estate on Oconomowoc Lake. After his death and the return to Chicago of his widow Clara, who remarried, there were some rocky times in which the estate changed ownership. David Dickson, a wealthy tea merchant, then stepped in and established the Springbank Hotel, a resort with an expansive bathing beach.

David Dickson ran the Springbank Hotel for many years, catering to a wealthy clientele. By 1891, however, a Mrs. J. A. Burlis was listed as its owner. In June 1909, sale of Springbank to the Catholic Chautauqua Association was revealed, along with plans to create a summer camp for boys and a permanent retreat center for men and boys.

Whether as a private residence, a summer resort, a camp, or as a monastery, Springbank's serene shoreline afforded a restful, contemplative environment. This tranquil lakeside scene belies the lively life and times of sea captain Tom Parker, whose father had been a British admiralty agent. Parker spent his vacations as a youth serving as a cabin boy on Mediterranean cruise ships. When his father died, Parker left Great Britain and invested his inheritance in an American sailing vessel. He continued to acquire cargo ships and eventually was reputed to be a Crimean War profiteer with the largest U.S. fleet. A founder of the Chicago Board of Trade, Parker did not come to Oconomowoc to merely dangle his feet off the pier. The casino he built on his property in 1877 was the backdrop for a 25th wedding anniversary cotillion that year that was reportedly the largest party in the state of Wisconsin during that entertaining season.

In 1928, Springbank was purchased by a small order of priests from Germany and Austria—the Cistercians of the Common Observance, established in 1098. They also were known as the White Monks and took upon themselves the role of guardians of art and music. During the Great Depression, the monks were forced to sell some of the mansion's elaborate furnishings in order to keep food on their tables. They also gradually removed many ornate touches in an effort to create a humbler living and prayer environment.

Even in winter, there was no denying the solid statement made by the structure known as Springbank. Eventually it became the retirement home of the late Archbishop William Cousins of Milwaukee. When the property was sold in 1985, the mansion was razed and the property subdivided for construction of large private residences. The Cistercians relocated to Sparta, Wisconsin, taking the remains of their brethren buried in the abbey cemetery with them. The property remains known as Springbank.

The Cistercian monks grew into a farming community, in part, raising beef cattle and farm crops and producing cheese, which they sold from a cheese mart on the monastery grounds.

The 1950s saw a building boom of sorts at the Cistercian Monastery, with the addition of an art studio, dormitories, dining hall, and cheese mart. The monastery was elevated to abbey status by the Catholic Church in 1972.

Okauchee and Okauchee Lake always have been known more as a resort community and did not serve as a focal point for the construction of summer cottages that made the transition to year-round estates. However, Capt. Tom Parker found it in his and his guests' interests to build a depot there in 1880, due to its proximity to his Springbank compound.

Talbot Dousman founded the community that bears his name in 1845. Elisha Edgerton and George Washington Van Brunt were the first two owners of property eventually donated by the Van Brunt family to the Masonic Consistory for what would become the Wisconsin Masonic Home retirement complex.

AIRPLANE VIEW, SILVER LAKE BEACH, NEAR OCONOMOWOC, WIS.--10

Silver Lake Beach and environs were a hotbed of considerably more than swimming during the Prohibition era.

BIBLIOGRAPHY

Babich, Mildred E., Robert J. Higgins, and David L. Smith. *A Town for All Seasons: Town of Oconomowoc, 1884–1994*. Oconomowoc: 1995.

Barquist, Barbara and David. *Oconomowoc: Barons to Bootleggers*. Oconomowoc: 1999.

Barquist, Barbara. *The Summit of Oconomowoc: 150 Years of Summit Town*. Summit History Group: 1987.

Early Oconomowoc Heritage Trail Guidebook. John S. Rockwell Questers' Chapter No. 721 and Daughters of the American Revolution, Oconomowoc Chapter 5046WI, 1975.

Historic Walking Tour Around Beautiful Fowler Lake. The Oconomowoc Area Chamber of Commerce, 2001.

Johnson, Jean Lindsay. *Illustrious Oconomowoc*. Oconomowoc: 1977.

———. *When Midwest Millionaires Lived Like Kings*. Oconomowoc: 1981.

Potter, Sandra Leitzke, Janet Leitzke Punko, and William H. Leitzke. *Historic Oconomowoc, Wisconsin*. Oconomowoc: 1993.

———. *Oconomowoc: 1920-1960, Book II*. Oconomowoc: 1995.

Swendson, Bill, Mary Swendson, and George Stalle. *1878–1978: La Belle Yacht Club*. Oconomowoc: 1978.

The Questers' Guide to Historic Oconomowoc. John S. Rockwell Chapter No. 720, The Questers, Incorporated. Oconomowoc: 1990.

Zimmerman, H. Russell. *The Heritage Guidebook Landmarks and Historical Sites in Southeastern Wisconsin*, 1976.

DISCOVER THOUSANDS OF LOCAL HISTORY BOOKS FEATURING MILLIONS OF VINTAGE IMAGES

Arcadia Publishing, the leading local history publisher in the United States, is committed to making history accessible and meaningful through publishing books that celebrate and preserve the heritage of America's people and places.

Find more books like this at
www.arcadiapublishing.com

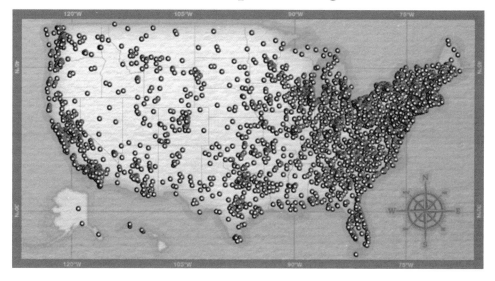

Search for your hometown history, your old stomping grounds, and even your favorite sports team.